Watercolor Paintings by Kari Naglestad

by Kari Naglestad
edited by Bob Cohen

copyright 2014
bobology

Watercolor Paintings by Kari Naglestad

by Kari Naglestad
edited by Bob Cohen

bobology
11278 Los Alamitos Blvd, #204
Los Alamitos, CA 90720
www.bobology.com

Copyright 2014 by bobology.

All rights reserved. Printed in the United States of America. Except as permitted under the Copyright Act of 1976, no part of this publication may be reproduced or distributed in any form or by any means, or stored in a database or retrieval system, without the prior written permission of the publisher.

bobology is a trademarks of Cohen-Naglestad Enterprises, LLC.

First Printing February 2014

Watercolors

Sand & Shore .. 3

Poppy .. 4

Tree ... 5

Swan in Water .. 6

Tulip .. 7

Troll ... 8

Alligator .. 9

Country Doorway .. 10

Butterfly & Lily .. 11

Dog and Toys ... 12

Birch Tree Forest ... 13

Marble Staircase .. 14

Castle .. 16

Berkeley House .. 17

Cottage ... 18

Picket Fence with Vine 19

Doorway with Window Pot 20

Hanging Flowers ... 22

Ribbons and Buttons 23

Kozzi Castle ... 24

Midwest Storm .. 25

Midwest Lightning 26
Snowdrift ... 27
Wave .. 28
Lake Sunset ... 29
Norway Fjord 30
Norwegian Mountains 32
Norwegian Coast 33
Northern Lights 34
Mushrooms from a Forest Floor 35
Norwegian Lake at Sunset 36
Duckling with Eggs 37
Unfinished Girl 38
Reprint Orders 39

Forward

I created this book as a convenient way for people to enjoy and view my late wife's watercolor paintings which are as much a part of her as anything she did. Kari had always thought it was her destiny to be a writer, and she did write three books, all of which are currently unpublished, because to her it was more important to have done them than to have other people see them.

She always had an affinity for color, and was very specific about anything she bought or did that involved color in any way. She even went into graphic design as a grad student to change her career so she could work with colors, but I don't think she knew it was color that appealed to her then. Even when it came to picking a car, her favorite choice was the vapor blue special edition VW beetle and she spent days searching for a model available in a dealer showroom.

Her manual dexterity and ability to work in detail was always remarkable and she used these skills for years in sewing, making costumes for her children, fabric gifts for her friends and family, and items for the house. She applied her love of color and detail to quilting and found her niche in appliqué. She filled our house with a palette of fabrics for every possible detail, finding colors that her friends were amazed even existed.

She always had a palette of paint and had talked about taking watercolor, and I think it was the subtlety and challenge of the medium that appealed to her. When she started taking classes later in life at Long Beach City College, it was because a friend, Fujiko Miller, helped her navigate the inner workings of the admissions system.

Once in, she was in her element and quickly started to master her detail skills, seen in some of the architectural paintings, with only a year of painting.

As an advanced student, she was required to come up with a goal for each semester. These themes came from Kari's life. Growing up as a young girl on a farm in Iowa which resulted in paintings of storms and lightning, her Norwegian heritage which

produced scenes from Norway, her favorite dog, Daphne, and her love of flowers of all kinds.

You can see her sense of humor in some of the paintings, like the goose, where we view the butt sticking up out of the water.

Many of her pieces were the result of her wanting to take on a challenge and master it. In many cases, the paintings would start, then be on hold for weeks, then start up again with complaints from Kari about how poor they looked. Then with a rush of effort she would turn out something like the wave, the beach, or a mushroom in a forest.

Kari started her watercolor painting in the Fall semester of 2010. The watercolors are shown in chronological order, from her first class, through the intermediate classes, then the advanced classes.

It took me several years of encouragement before she was willing to show her friends her work. I was finally able to do it by putting pictures on my smartphone and when we would go out on errands, and people would ask her what she was up to, I would show her paintings to people. Everyone was enthusiastic and gradually she began to build up her confidence. One day she finally came home and told me she wanted the pictures on her smartphone so she could show them to her friends.

Enjoy each one, turn each page slowly, drink in the color and images, and it will be just like she would show them to you herself.

Bob Cohen

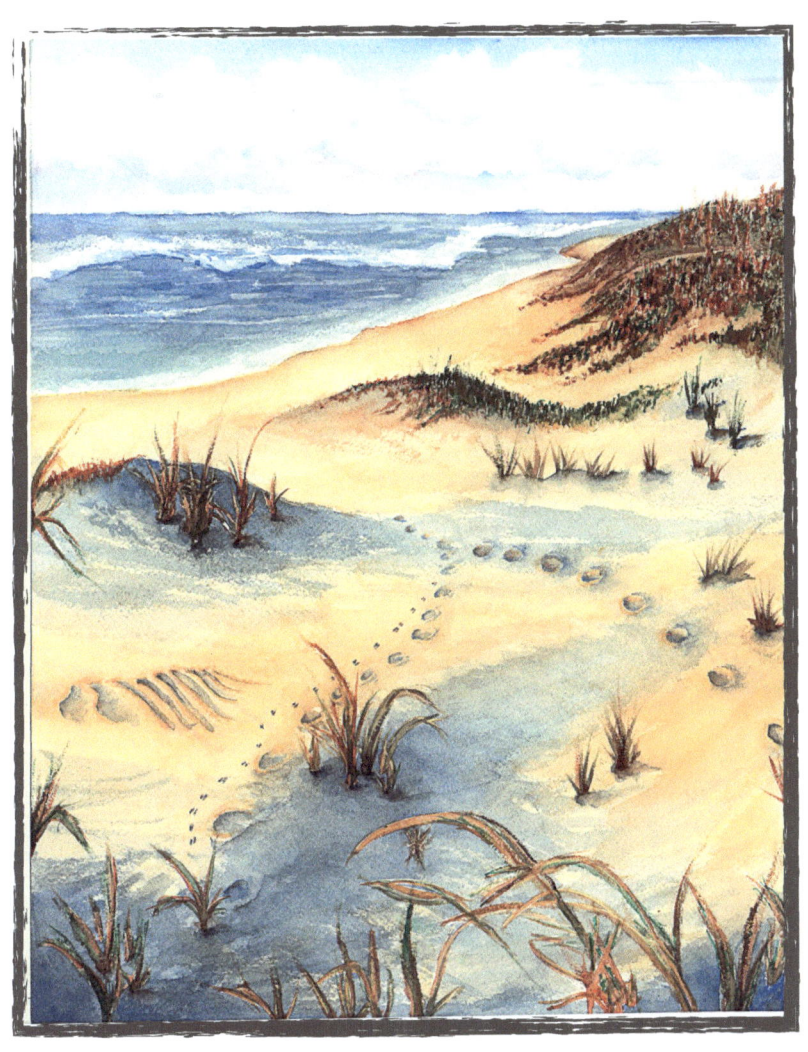

Sand & Shore

2nd Landscape
October 2010
Beginning Watercolor Painting
Original 12.5x16 inches

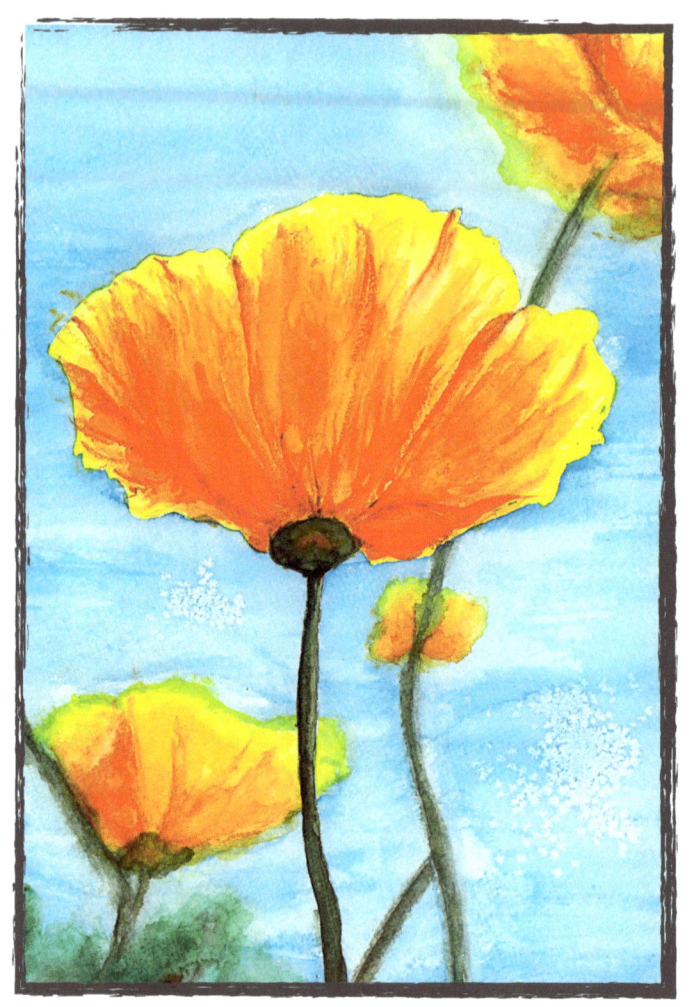

Poppy

October 2010
Beginning Watercolor Painting
3rd Watercolor Painting
Open Assignment
Original 10x14.75 inches

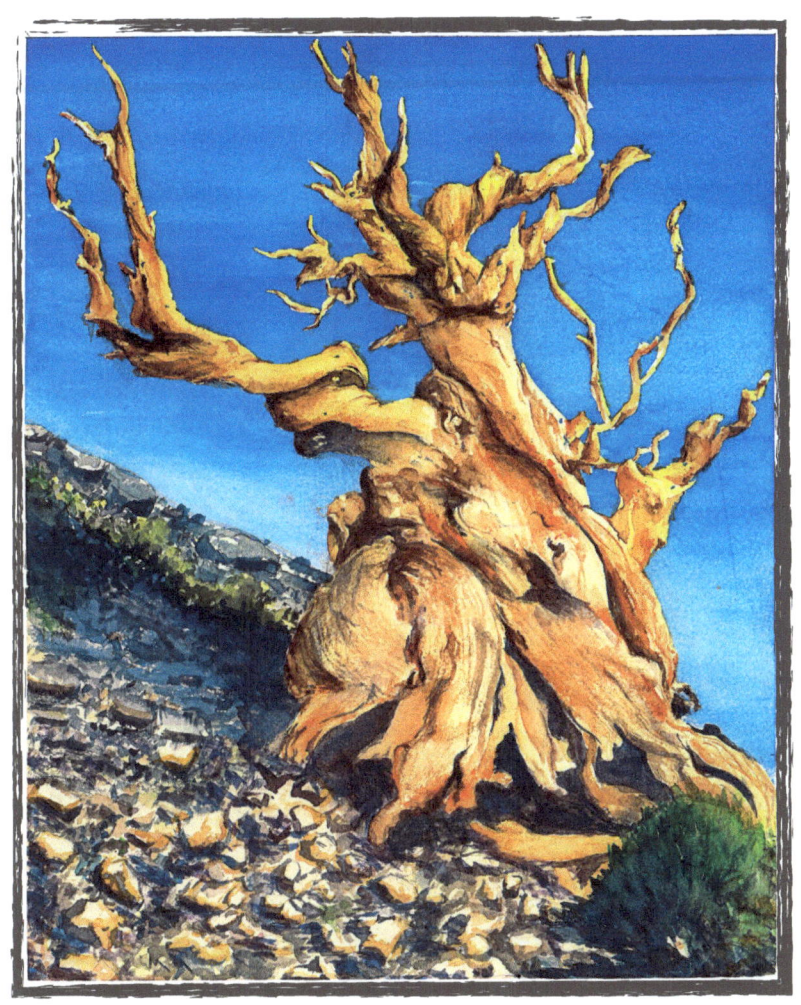

Tree

December 2010
1st Watercolor Painting -Landscape
Beginning Watercolor Painting
Original 11.5x14.5 inches

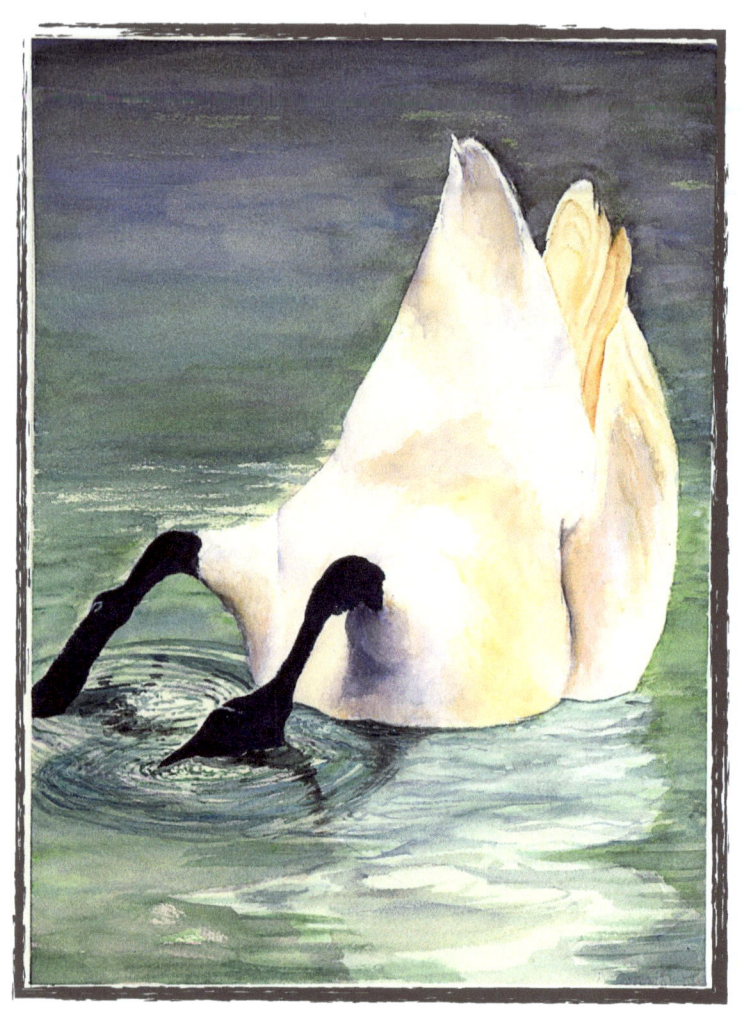

Swan in Water

December 2010
Beginning Watercolor Painting
Original 11x16 inches

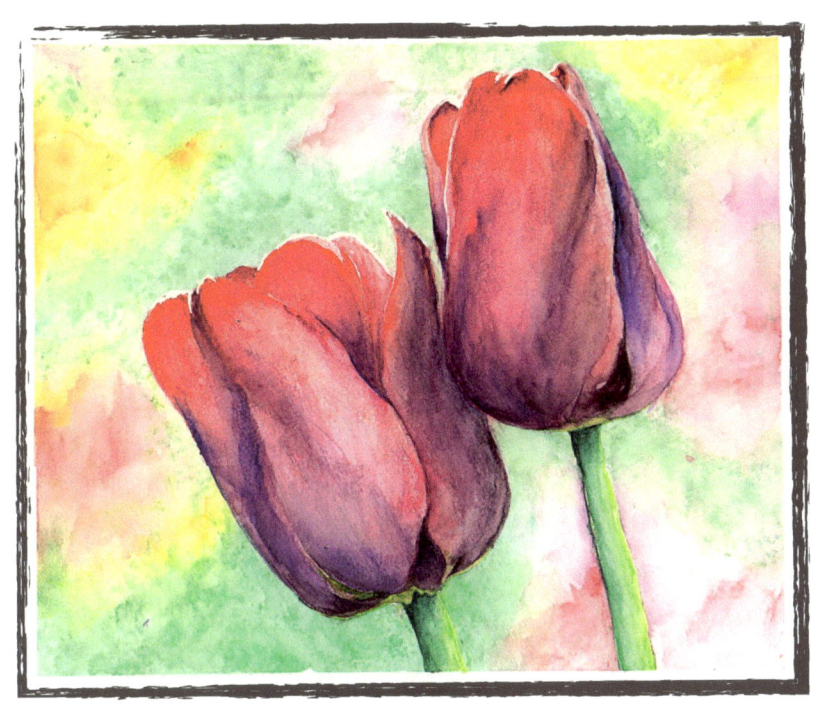

Tulip

December 2010
Beginning Watercolor Painting
Original 14x12 inches

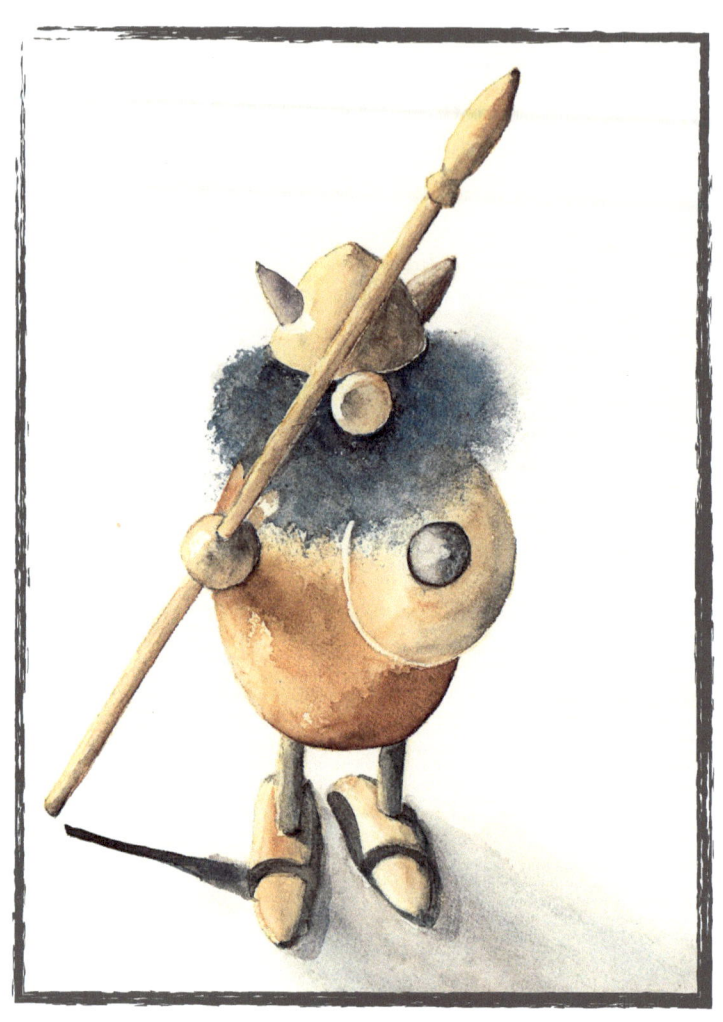

Troll

December 2010
Beginning Watercolor Painting
Original 10.25x14 inches

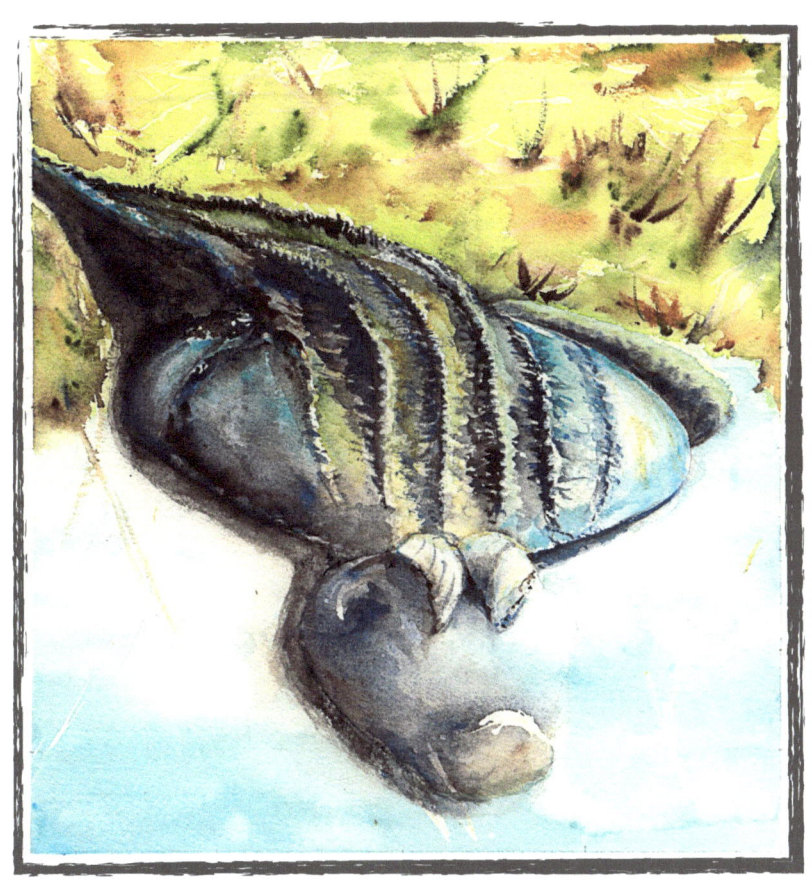

Alligator
Undated
Original 10x11 inches

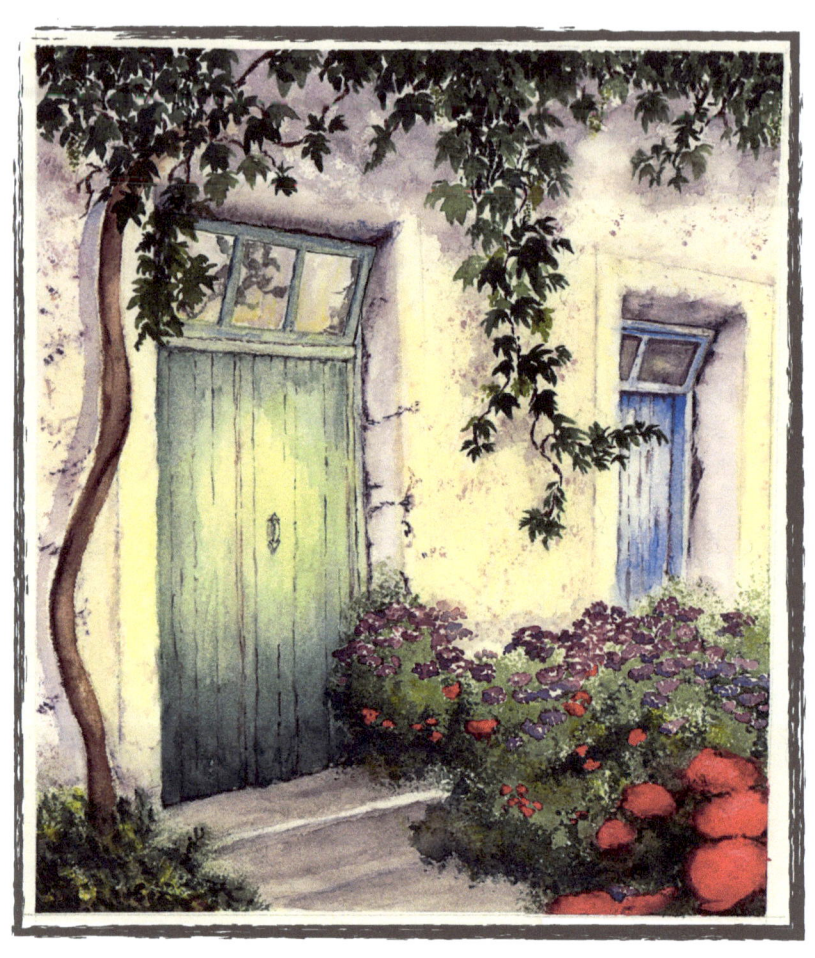

Country Doorway
March 2011
Intermediate Watercolor
Original 11.5x13.75 inches

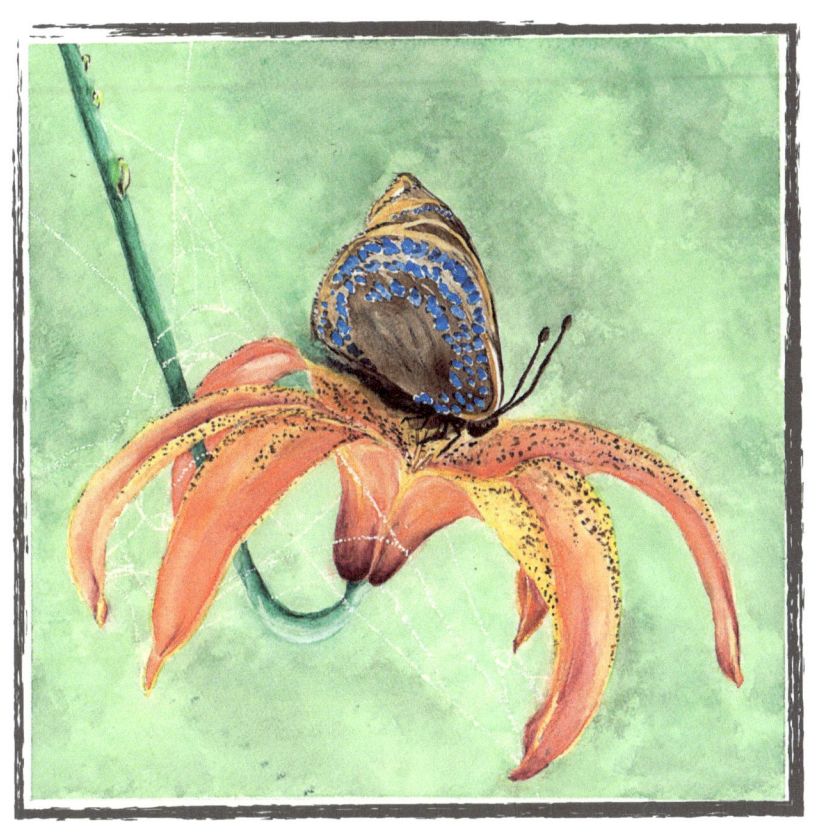

Butterfly & Lily

March 2011
Intermediate Watercolor Painting
Original 13x13 inches

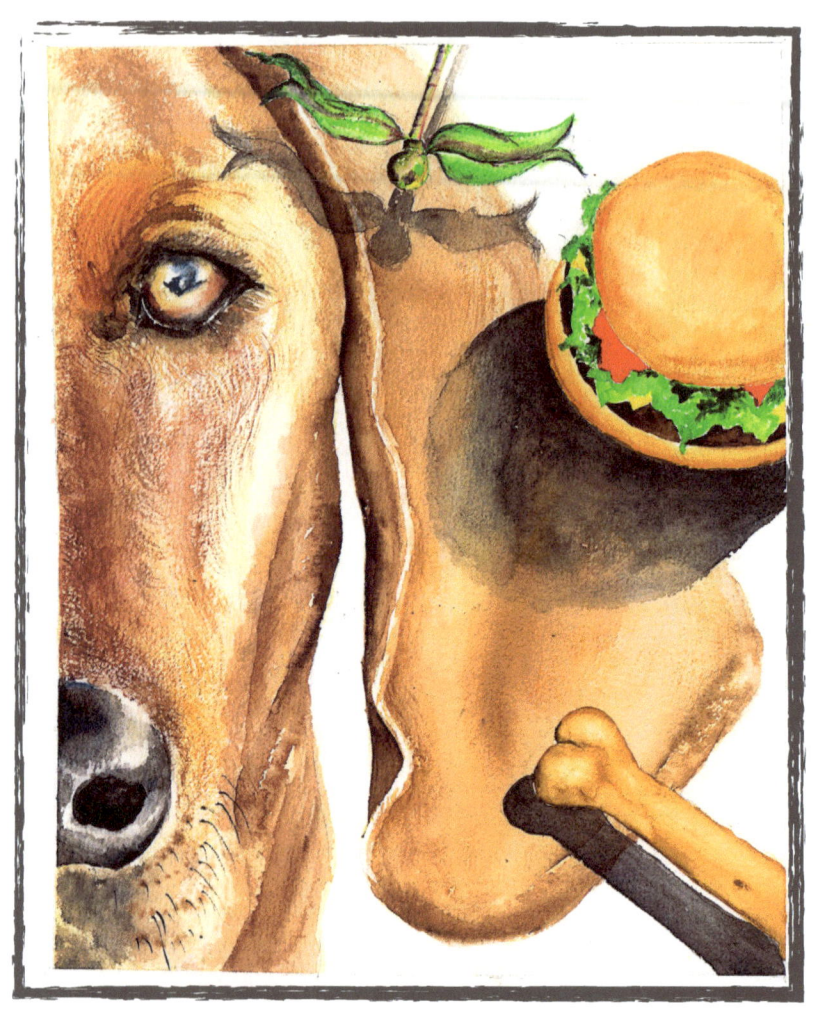

Dog and Toys
May 2011
Intermediate Watercolor Painting
Original 12x15 inches

Three objects and shadows. Her dog, Daphne, and two rubber toys.

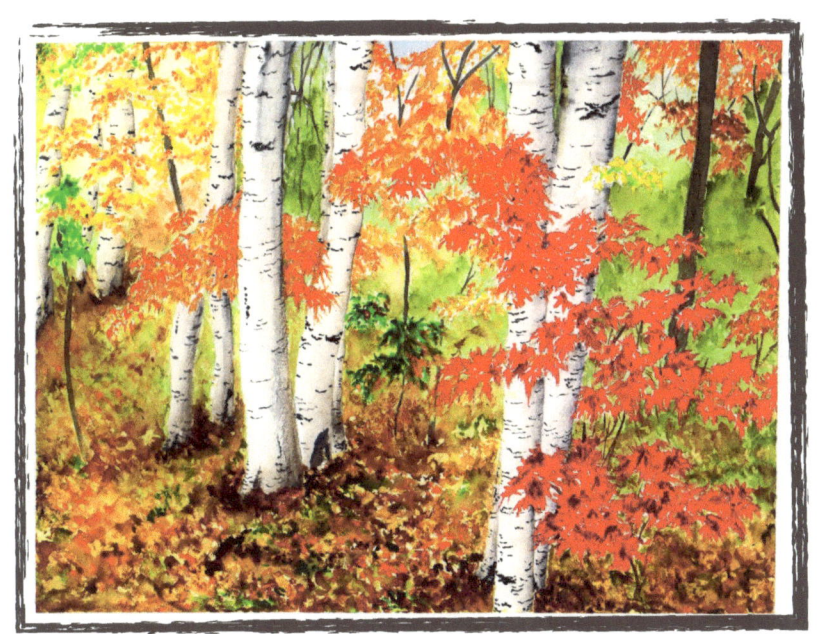

Birch Tree Forest

May 2011
Intermediate Watercolor Painting
Original 13x10.25 inches

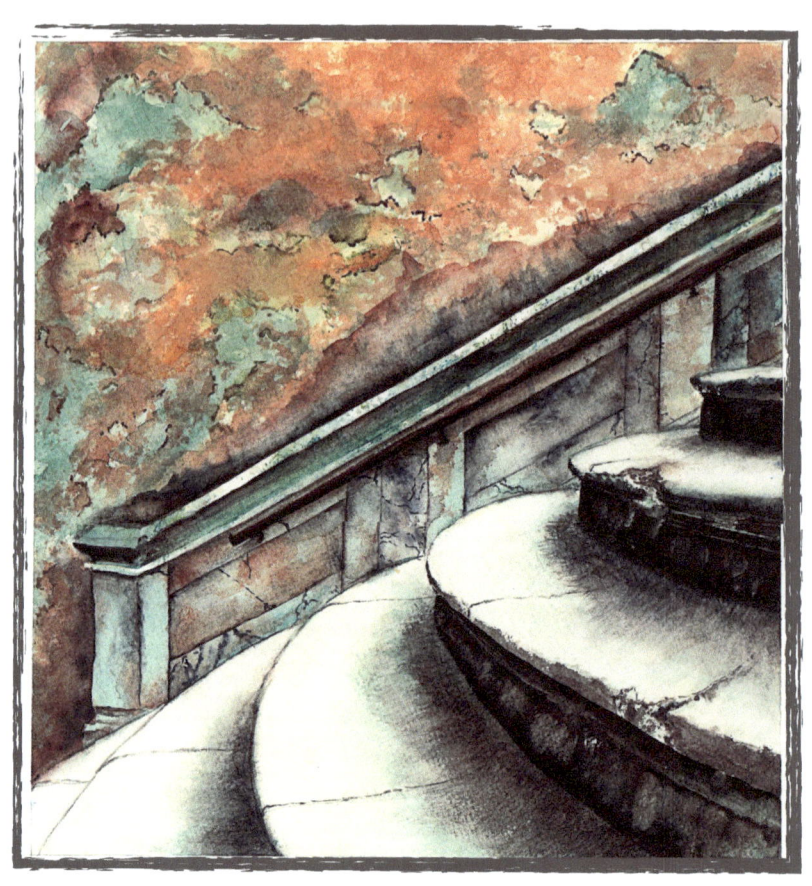

Marble Staircase

May 2011
Intermediate Watercolor Painting
Tone Wash Painting
Original 11.5x12.5 inches

Fall 2011

Advanced Watercolor, 25BD

Fall Semester 2011, M-W mornings

Kari Naglestad

This semester I am proposing to paint a series of buildings and/or structures of various sizes, shapes, purposes, textural and architectural styles.

This idea intrigues me because there are so many challenges from one possibility to the next, and I have no idea at all if I'll be able to make the buildings I paint come out the way I see them in my mind's eye. (If they turn out terrible, then I reserve the right to call them abstracts or nonobjective studies.)

I am not as concerned with architectural perfection as I am in being able to express through my painting the character of each structure and the feelings each evokes.

I'm rather new at this and am not sure how difficult these projects will turn out to be, so I propose completing at least four paintings, and if possible, as many additional ones as time will allow.

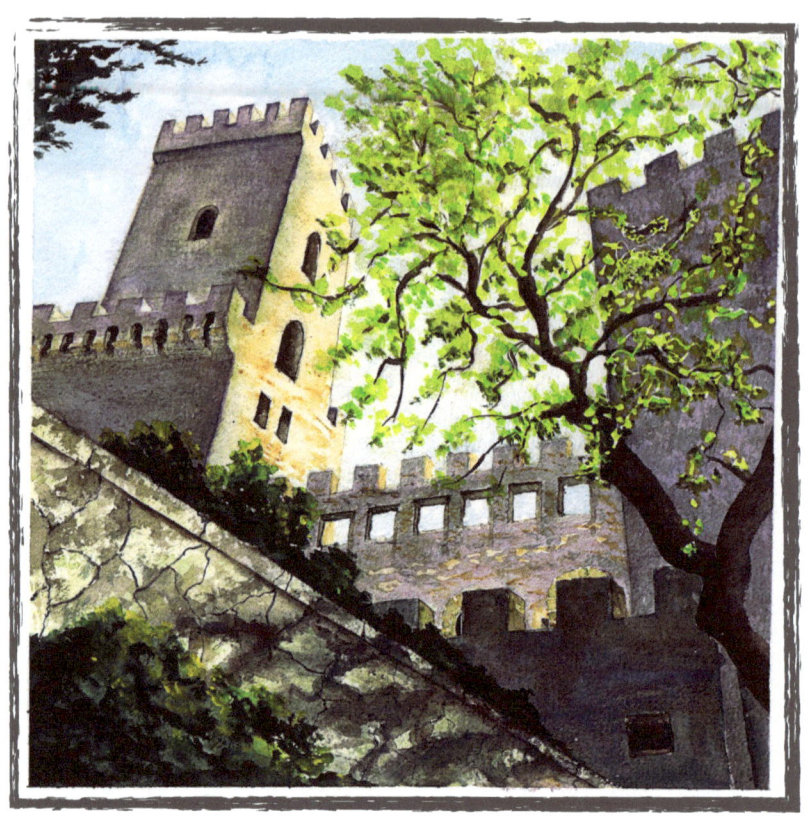

Castle

October 2011
Intermediate Watercolor Painting
Original 12x12 inches

Kari always liked castles so she chose one for perspective.

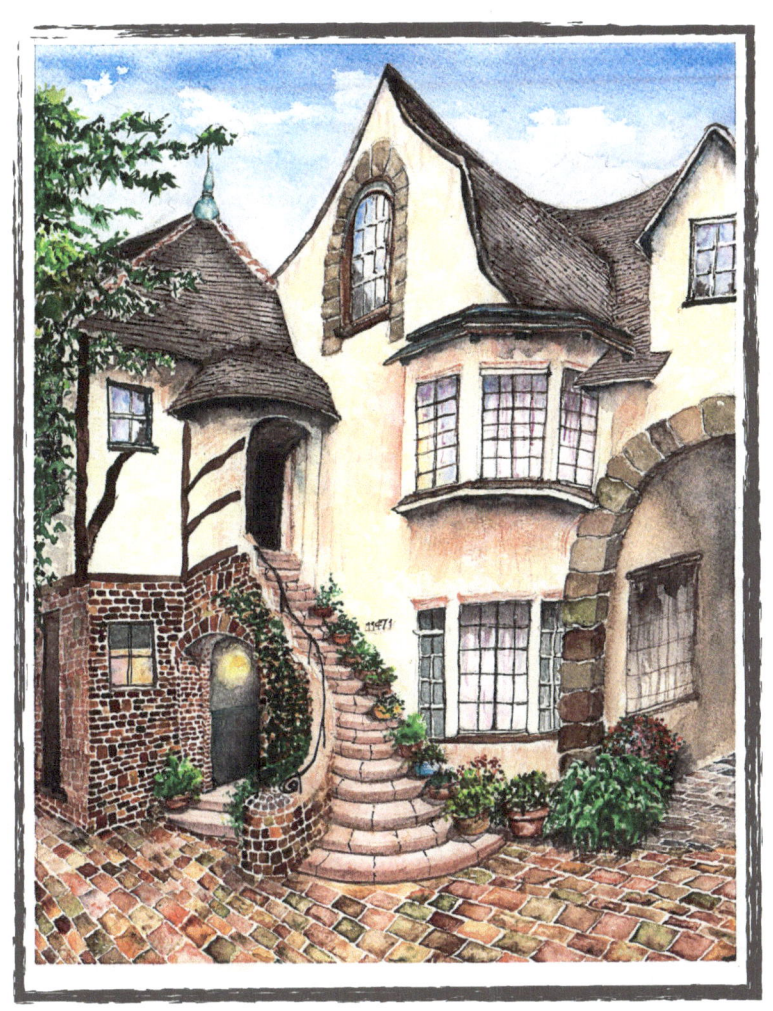

Berkeley House

October 2011
Intermediate Watercolor Painting
Original 10.25x13.75 inches

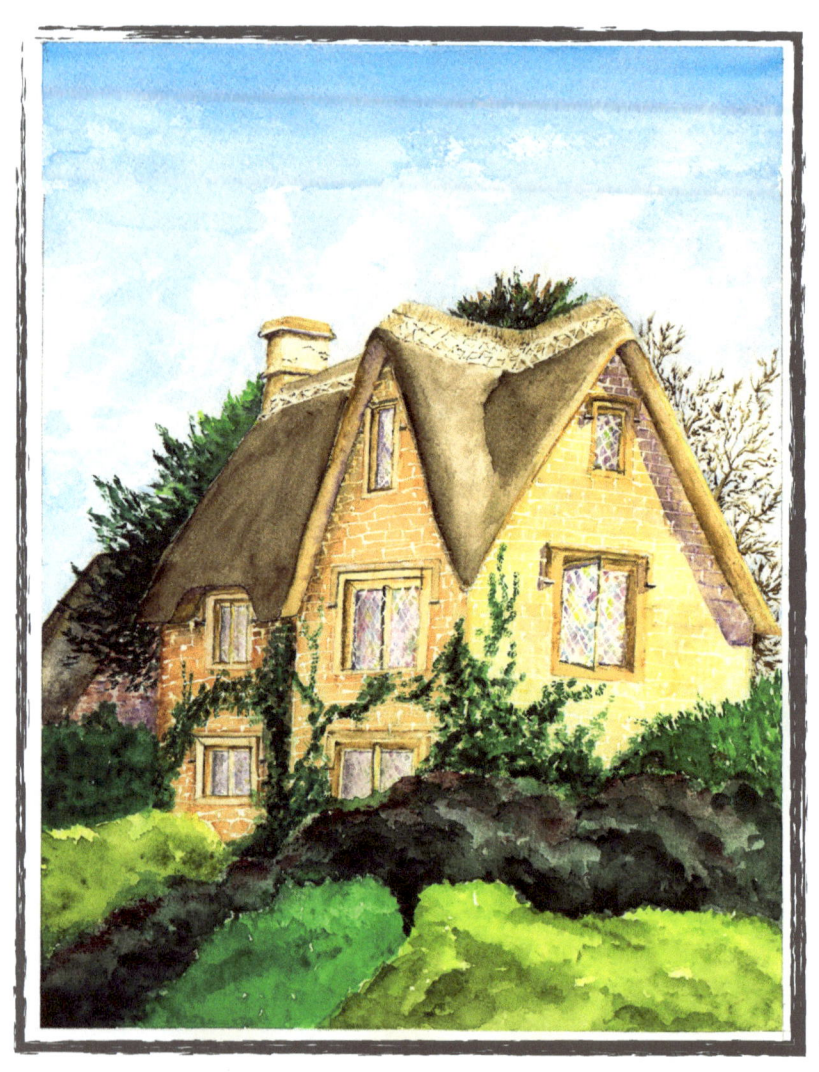

Cottage

October 2011
Intermediate Watercolor Painting
Original 10x13.5 inches

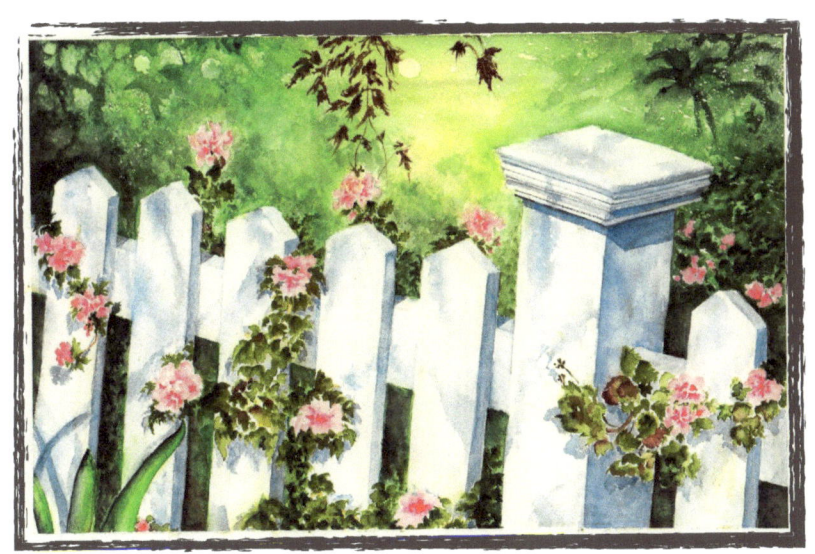

Picket Fence with Vine

December 2011
Original 14x9.5 inches

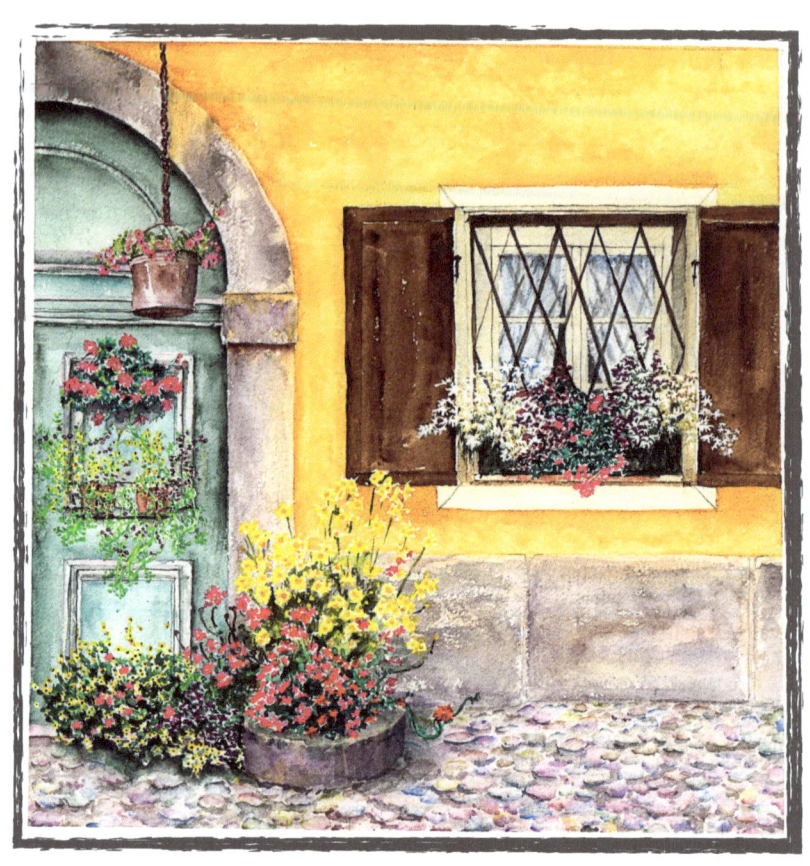

Doorway with Window Pot

December 2011
Intermediate Watercolor Painting
Original 12x12.5 inches

Spring 2012

Kari Naglestad

Advanced Watercolor, 25 BD
Spring Semester 2012

For this semester I propose painting a series of projects dealing with subjects and/or techniques that have always intimidated or challenged (ie, *scared*) me. There are many, many possibilities that can be included in this category, so in an effort to narrow down the list, I'll tentatively suggest: a sunset, storm clouds, some kind of landscape with water or waves, possibly snow, a relatively intricate flower, *maaaaaayybeeeeee* some cut crystal or glassware (however, please be aware that I'm not completely *committing* to this one ~ to be blatantly honest about my own limitations, it might just turn out to be a fanciful idea …), or anything else my little ol' brain decides to take hold of and try to wrestle to the ground.

As for the number of finished paintings, I wish I could be able to tackle huge quantities of masterpieces. But I have been learning about myself that at the pace I seem to work, a realistic amount that I figure I can do justice to would be more in the range of about four paintings, covering a mixture of the above subjects or similar, by mid-May. I'm hoping I can accomplish more than this, and promise to work diligently to do so, but we won't assume anything. This way, if I end up with more than four, we'll all be pleasantly surprised!

Oh, and if my self-esteem takes too much of a beating with the above assignment, then I reserve the right to fall back on Plan B: a series of wet-in-wet Rohrschach (sp?) test symbols ~ in an exciting variety of colors, naturally.

;-)

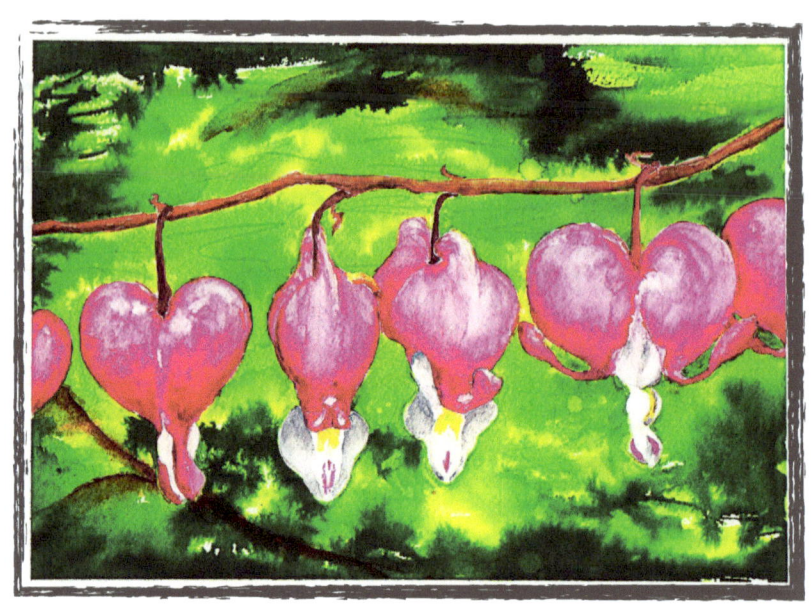

Hanging Flowers

May 2012
Advanced Watercolor Painting
Original 10x7 inches

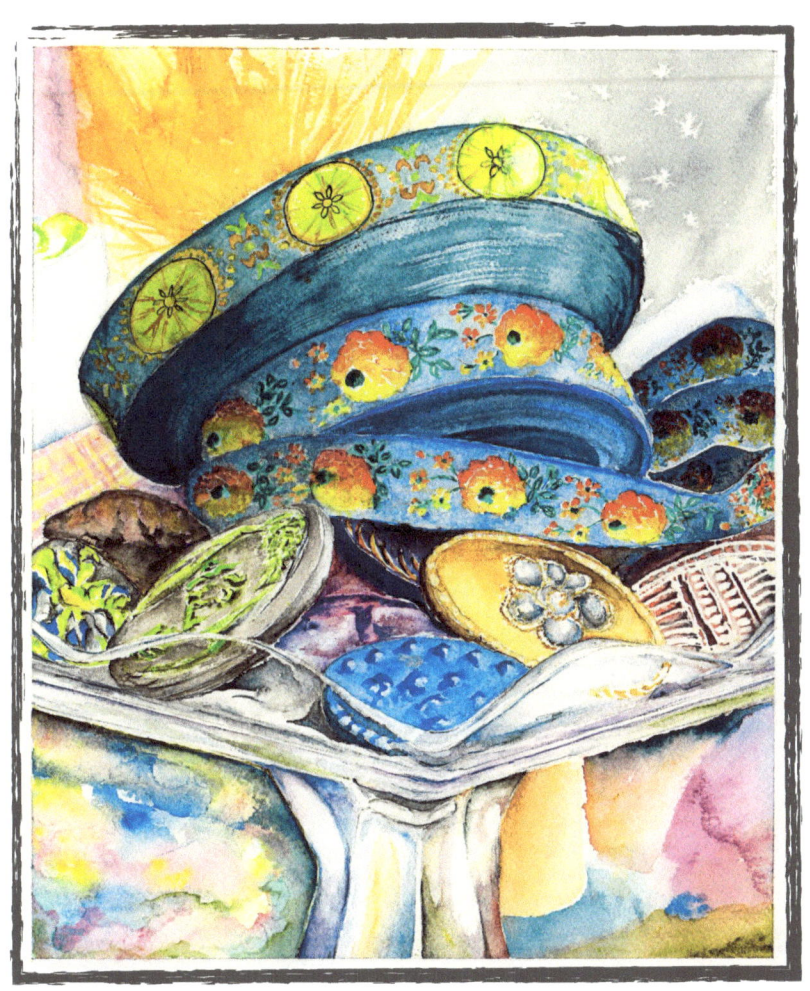

Ribbons and Buttons

May 2012
Advanced Watercolor Painting
Original 8.5x10.5 inches

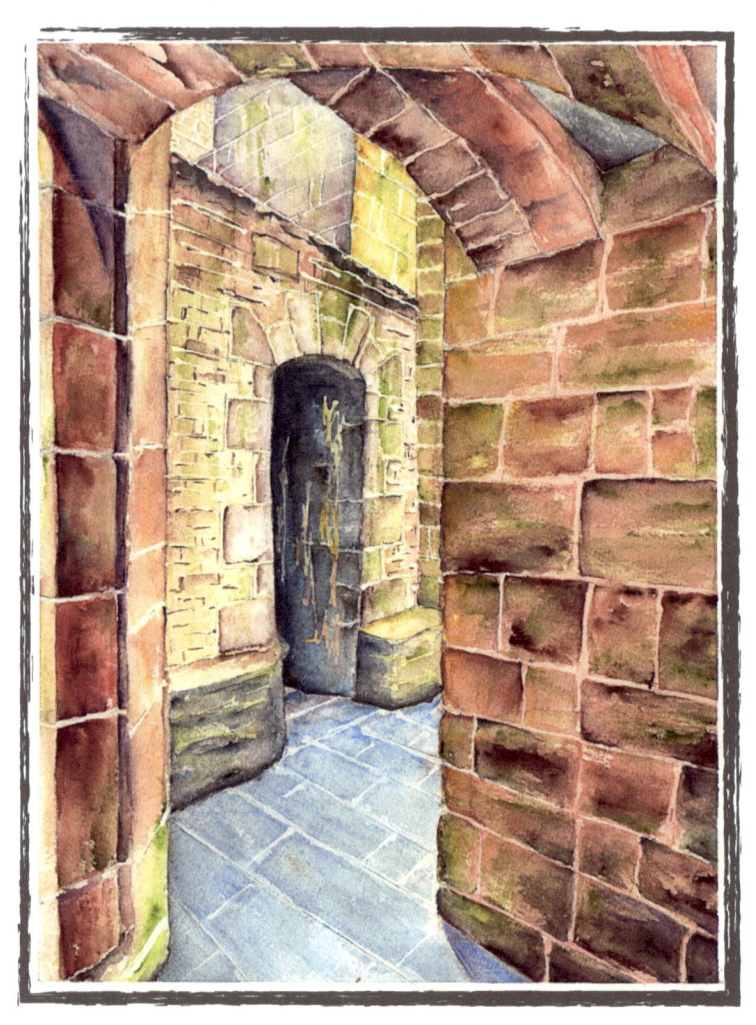

Kozzi Castle

May 2012
Advanced Watercolor Painting
Original 10x14 inches

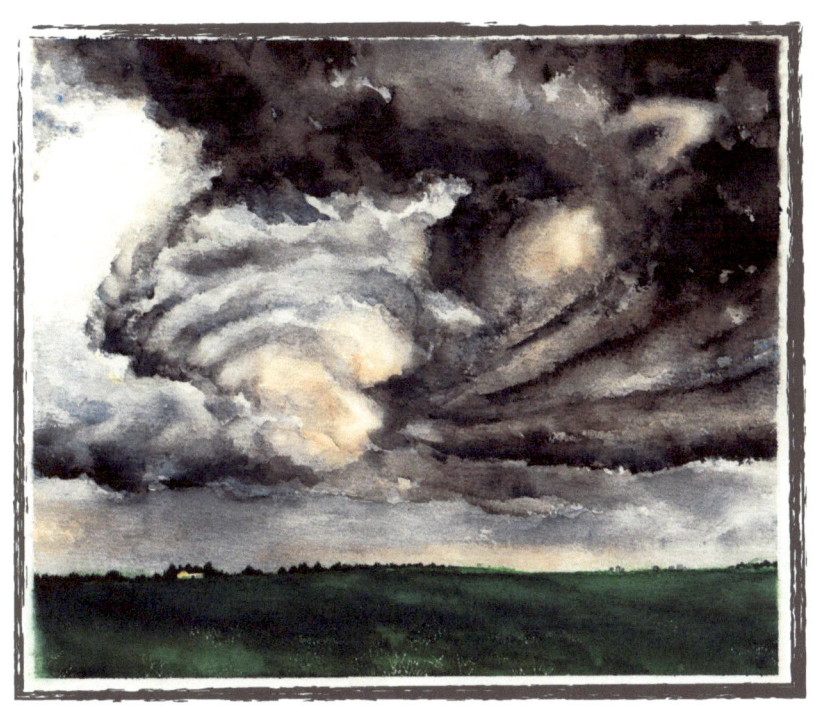

Midwest Storm

Spring 2012
Advanced Watercolor Painting
Original 13.75x12.25 inches

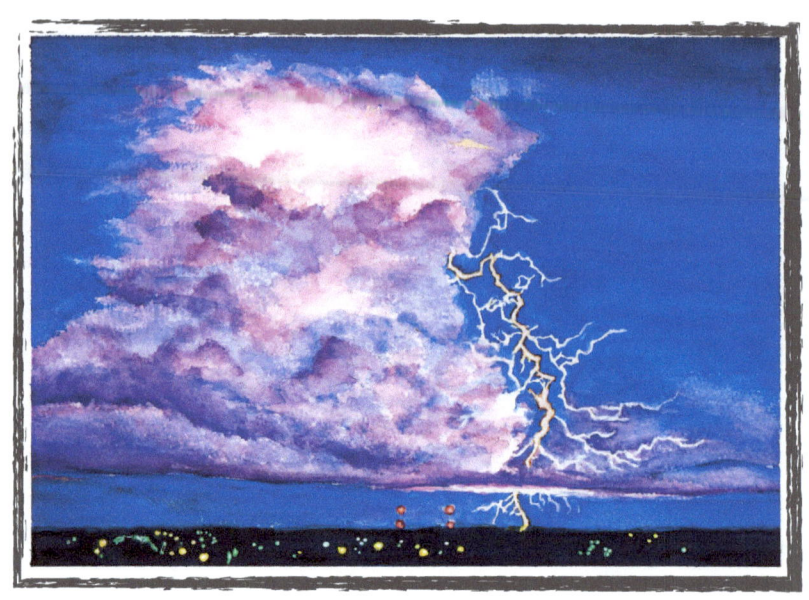

Midwest Lightning

Spring 2012
Advanced Watercolor Painting
Original 13x9.25 inches

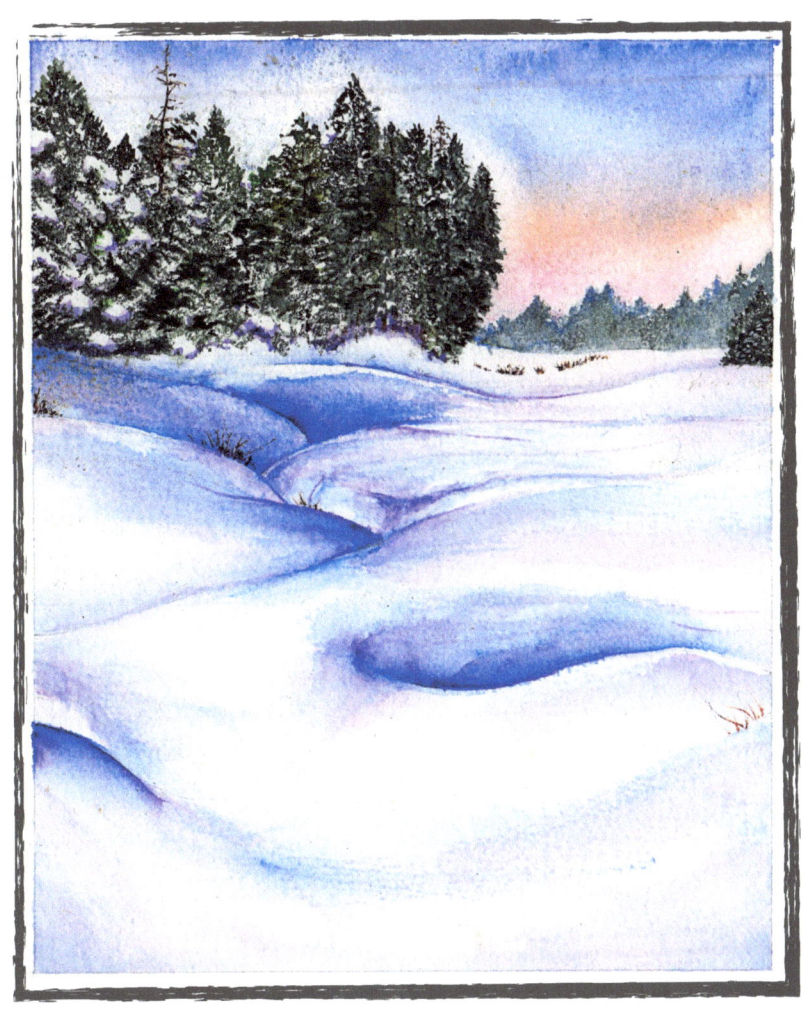

Snowdrift

Spring 2012
Advanced Watercolor Painting
Original 9x11.5 inches

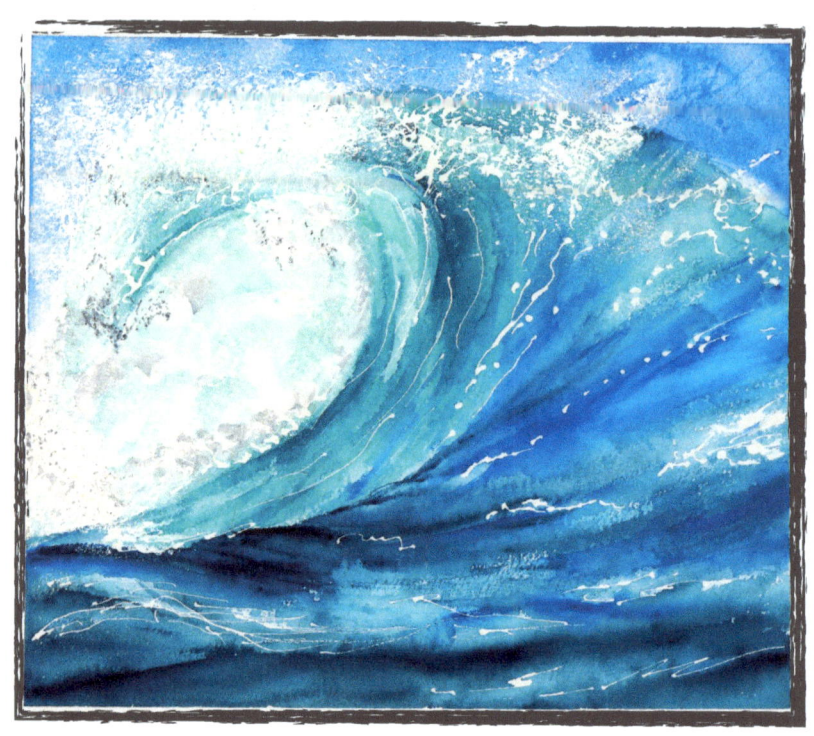

Wave
May 2012
Advanced Watercolor Painting
Original 11x9.75 inches

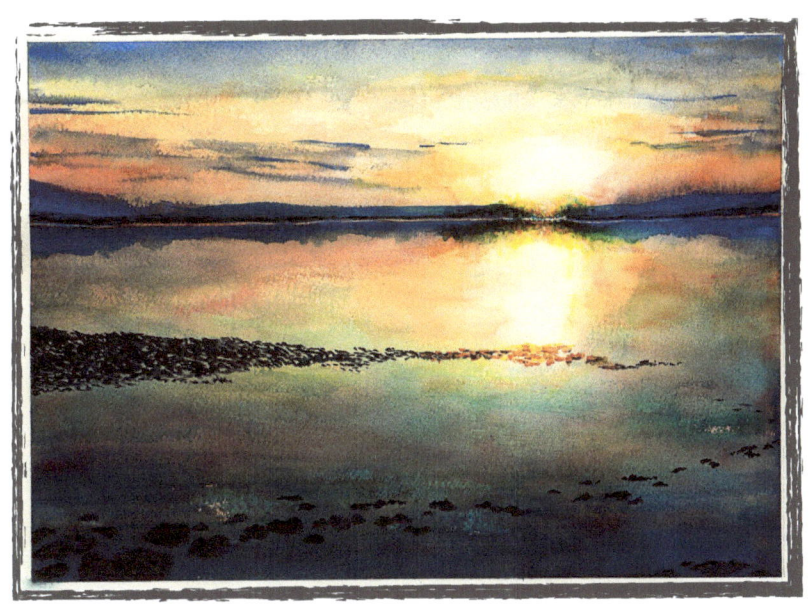

Lake Sunset

Spring 2012
Advanced Watercolor Painting
Original 14x10 inches

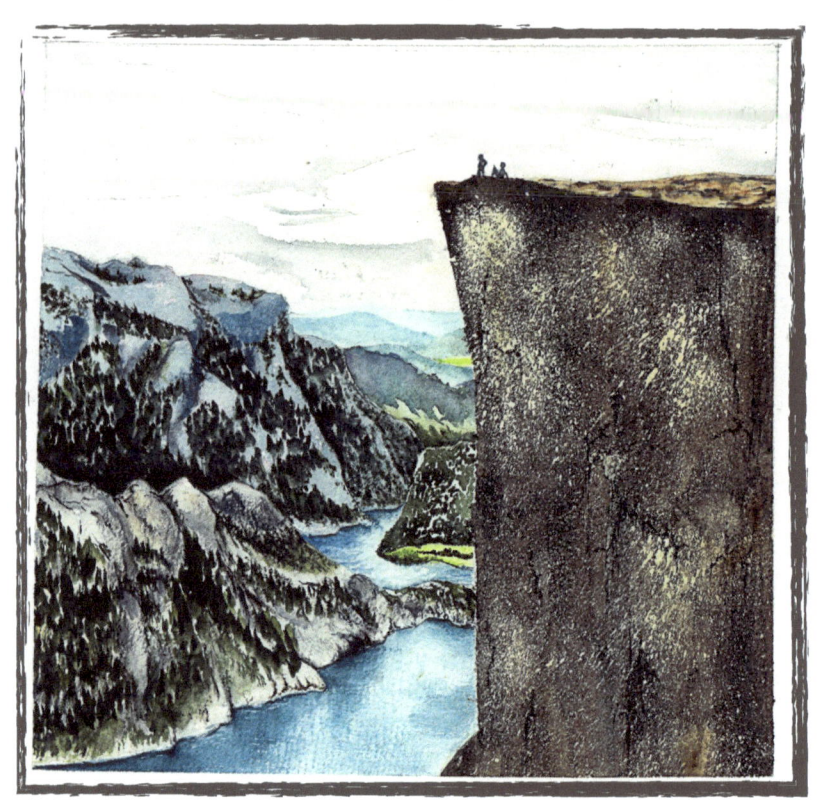

Norway Fjord

December 2012
Memories of Norway
Advanced Watercolor Painting
Original 10.5x10.5 inches

Fall 2012

Kari Naglestad

Proposal ~ Advanced watercolor painting

Fall 2012

Instructor ~ Mike Daniel

This semester I want to do a series of paintings based on photographs I took when I was traveling through Norway about two years ago. The subject is near and dear to my heart because I am Norwegian, and my visit there really seemed to strike a deep chord. I'm curious to see if my painting efforts will be able to translate my deep-seated feelings about the land and its people onto paper. Who knows? I hope so.

I'm not sure how my paintings of Norway will turn out, nor can I estimate exactly how many I'll be able to do. But it has been realistic in the past for me to expect to do at least four projects during the semester, so that's what I'll plan on this time. If I am able to do more, I will. I feel confident, however, in promising that the final number will definitely be less than twenty. (I want to be considerate and not saddle you with an excessive number of masterpieces to evaluate, Mike. Ain't I thoughtful???)

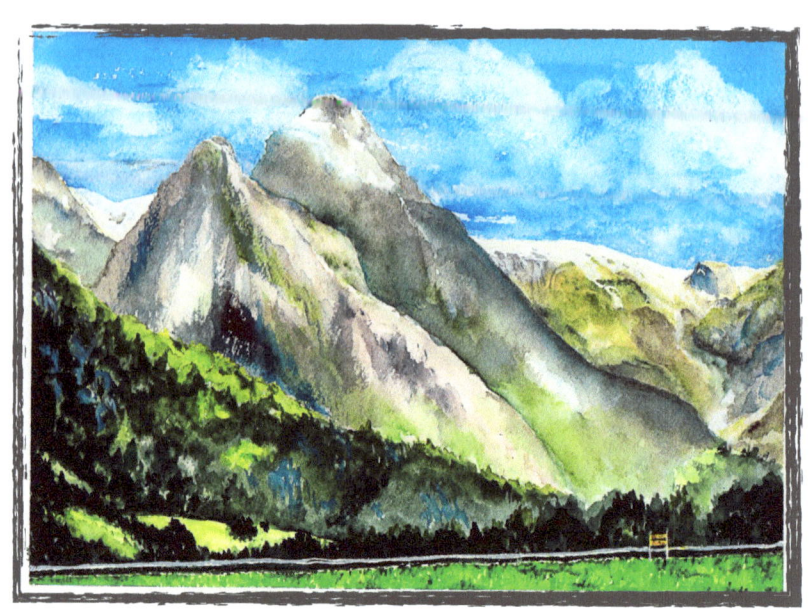

Norwegian Mountains

Fall 2012
Memories of Norway
Advanced Watercolor Painting
Original 11.25x8.25 inches

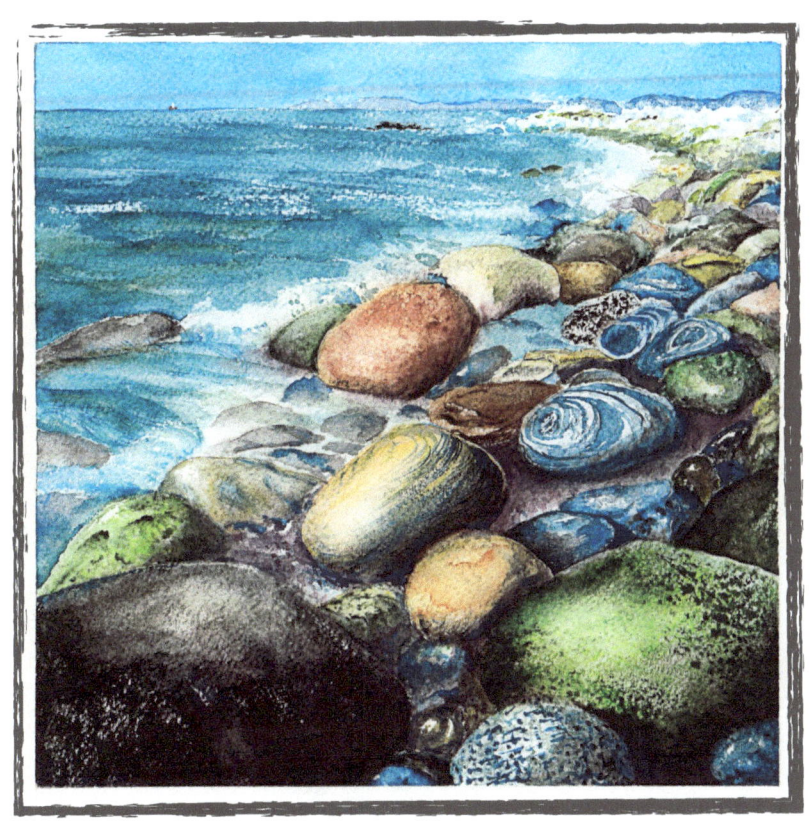

Norwegian Coast

Fall 2012
Memories of Norway
Advanced Watercolor Painting
Original 8x8 inches

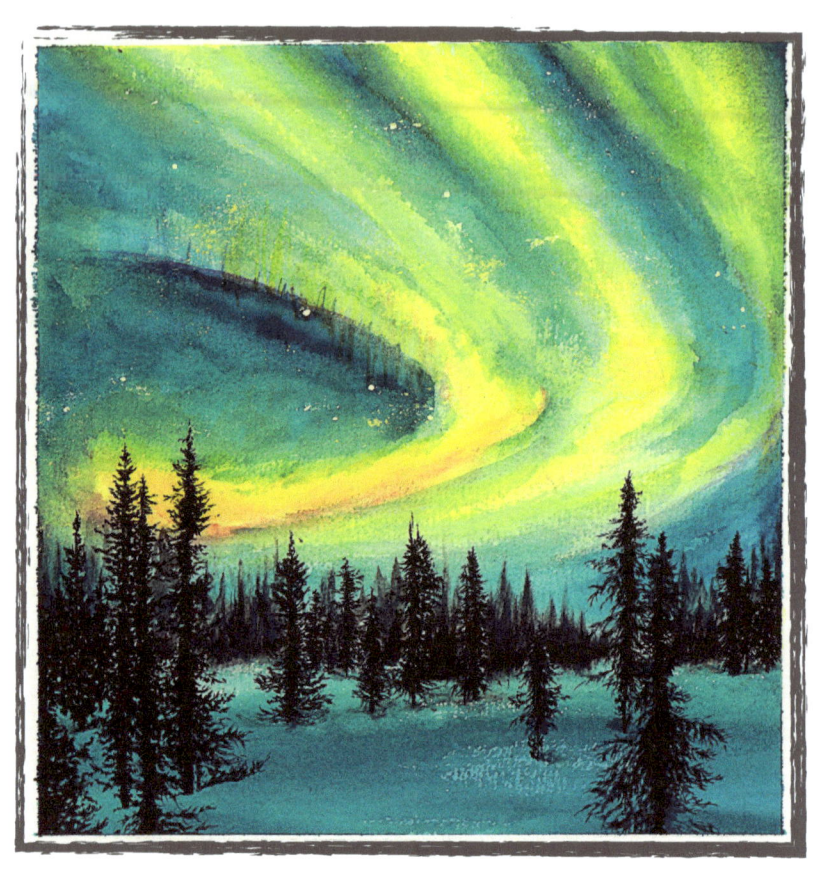

Northern Lights

Fall 2012
Memories of Norway
Advanced Watercolor Painting
Original 12x12.5 inches

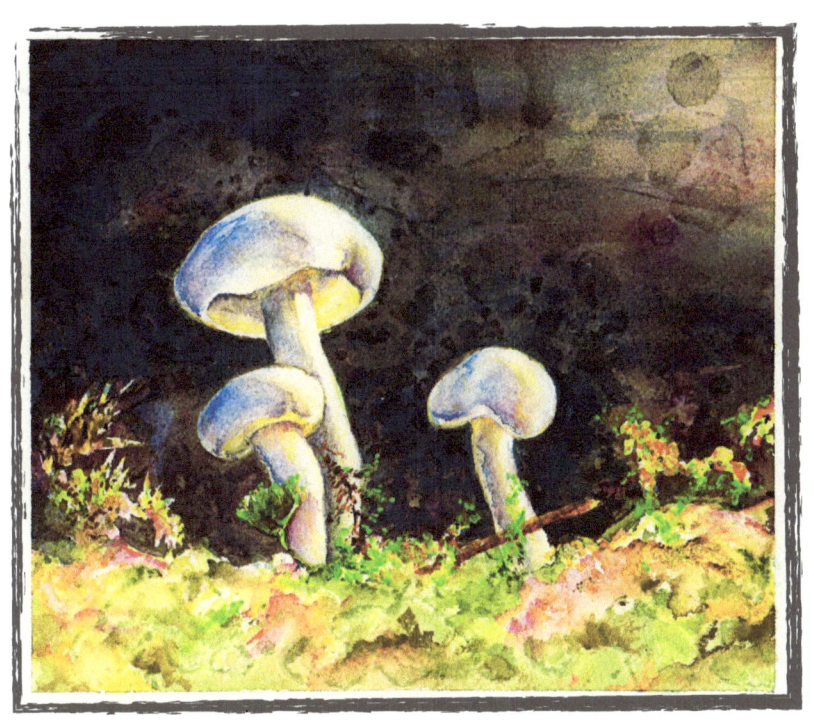

Mushrooms from a Forest Floor

Spring 2013
Advanced Watercolor Painting
Original 8x7 inches

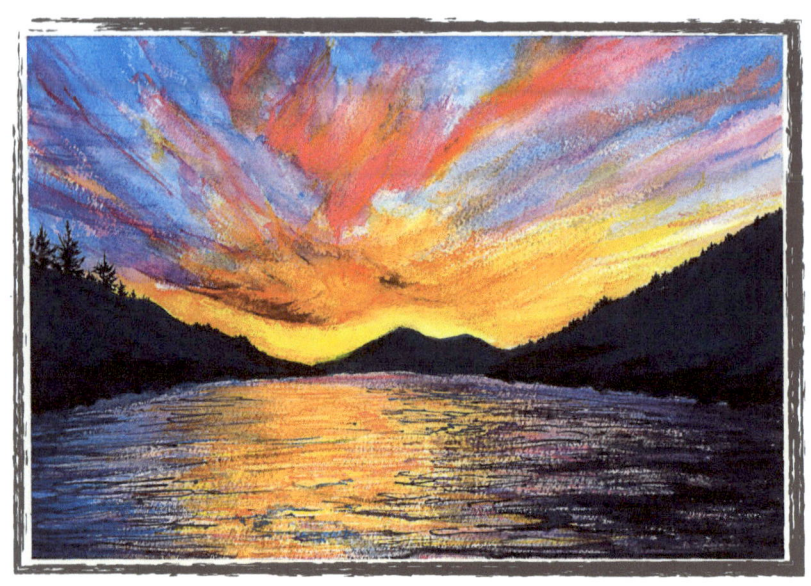

Norwegian Lake at Sunset

Spring 2013
Memories of Norway
Advanced Watercolor
Original 13x9 inches

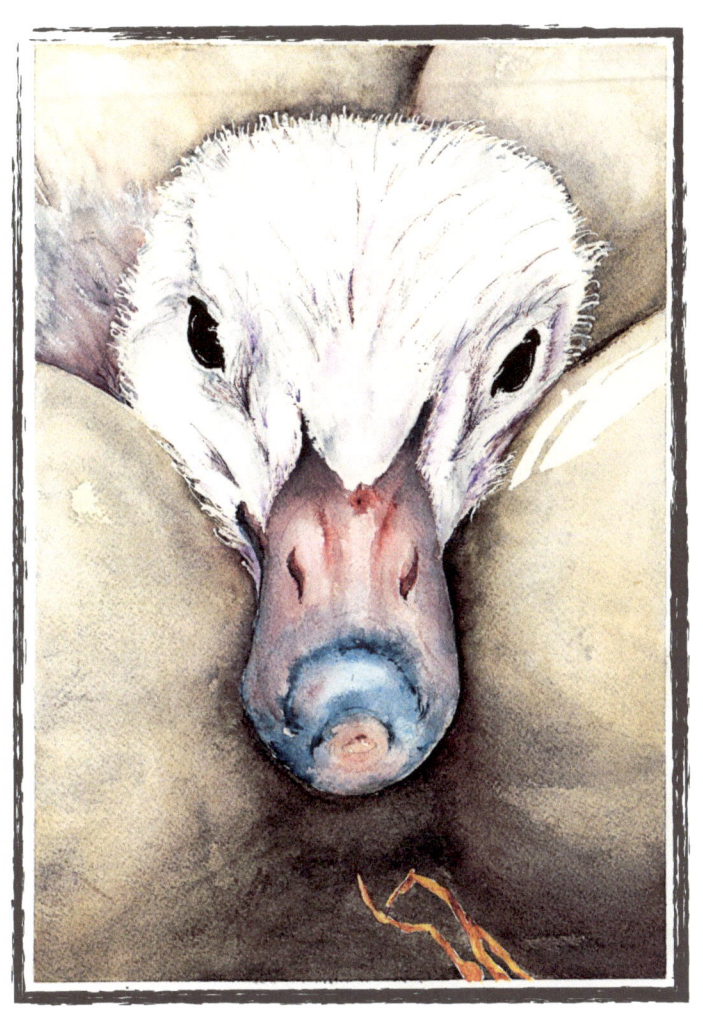

Duckling with Eggs
Spring 2013
Advanced Watercolor Painting
Original 8.5x12.25 inches

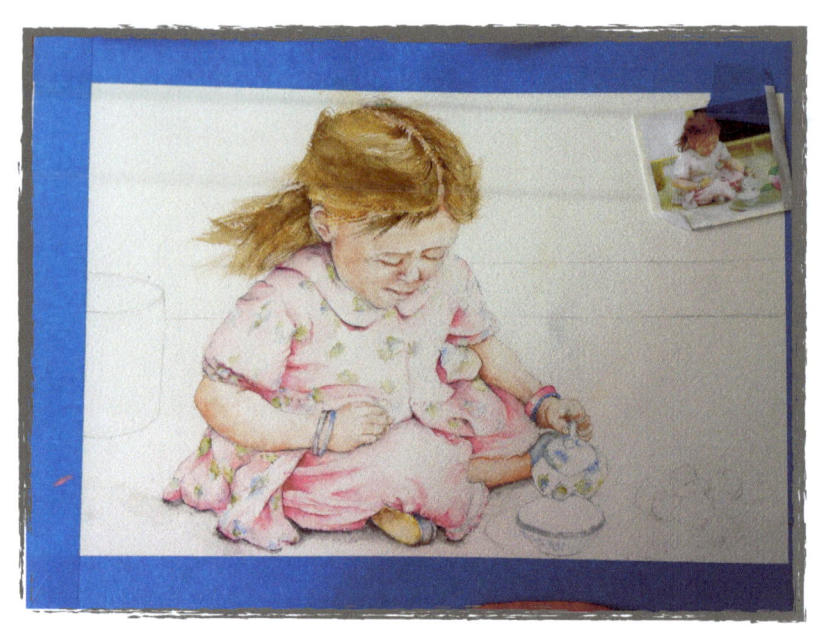

Unfinished Girl
Spring 2013
Advanced Watercolor Painting

Reprint Orders

High quality original size color reprints are available on the bobology website at this page:

www.bobology.com/watercolors.html

You can read more about Kari at this website:

http://karinaglestad.blogspot.com/

www.ingramcontent.com/pod-product-compliance
Lightning Source LLC
Chambersburg PA
CBHW040928180526
45159CB00002BA/650